The Carver's Handbook:

Woodcarving Wild Animals

by David E. Pergrin

Schiffer Publishing Ltd

Box E, Exton, Pennsylvania 19341

D1445390

Dedicated to
Monsignor Frederick Stevenson,
Sister George Thêrêse,
and the Woodcarving Class of 1985.

Printed in the United States of America.
ISBN: 0-88740-039-6
Published by Schiffer Publishing Ltd. 1469 Morstein Road, West Chester, Pennsylvania 19380

This book may be purchased from the publisher.
Please include $1.50 postage.
Try your bookstore first.

Contents

Preface

The Boy Scout Oath and Law have aided many boys around the world to grow up loving God and Country. In my own life, I have benefited from following the Scout Oath and Law and participating in the rigors of outdoors within the Scout program.

This background served me well in World War II when I trained and commanded the highly decorated 291st Engineer Combat Battalion which gallantly performed in the "Battle of the Bulge" and at Remagén on the Rhine.

The twelfth law is "A Scout is reverent" and without prayer and sincere reverence I know that the 291st and the scout world would not have been of such high quality in the performance of their missions.

The carvings in this book are designed to aid beginning, intermediate, and professional carvers of all ages.

The cardinal is included in this book not only to give me the opportunity to make Monsignor Frederick Stevenson a "Cardinal", but to satisfy the many requests I have had to show in a book how to carve most everyone's favorite bird.

The Cardinal

Materials Needed

Band saw, coping saw, or jigsaw
Rotary grinder or hobby tool with
 circular saw bit
 1/8" Drill bit
 Sanding drum with fine grain sleeve
One basswood block, American Linden
 3" x 4" x 6½"
1/64" birch plywood (3 ply)
X-acto carving knives

Sand paper
Scissors
Cardinal's feet and legs from supplier
Alcohol
Water
Hair dryer
Paint brushes, No. 3 and No. 0
Epoxy putty
5-minute epoxy glue

Acrylic paint
 Mars Black
 Cadmium Red light
 Titanium White
 Burnt Sienna
Burning pen
Superglue
Two glass eyes (6 mm)

The male cardinal is an all-red bird with a pointed crest, and a black patch at the base of its triangular shaped orange-red bill. It ranges from Southern Ontario to the Gulf States, Mexico to Honduras, and Southwest United States. Its habitat is in the edges of woodlands, thickets, suburban gardens, and farmlands. Its favorite food is sunflower seeds and its attractive song is clear slurred whistles—"what-cheer cheer cheer cheer." Its size is 7" to 9 1/2" with a slender body.

The wood we recommend comes from the American Linden tree, commonly called basswood. Basswood is easy to work, holds paint well, textures easily with a burning pen, and glues nicely. It grows as a tall, stately tree sometimes reaching 120-140' in height and 4-4 1/2' in diameter. It is available from lumbermen in Northeast Pennsylvania.

The wood that is used for the cardinal's tail feathers is yellow birch 3 ply 1/64" plywood. It is heavy, hard, strong, stiff and has very high shock resistance and thus makes excellent wood for feather inserts. The wood can be obtained at hobby shops.

Using the pattern shown in figure 1, cut out the body using a jigsaw, band saw, or coping saw from a 3" x 4" x 6 1/2" block of basswood. If you need help to make the cutout. take your pattern to a carpenter's shop to make the cardinal blank for you.

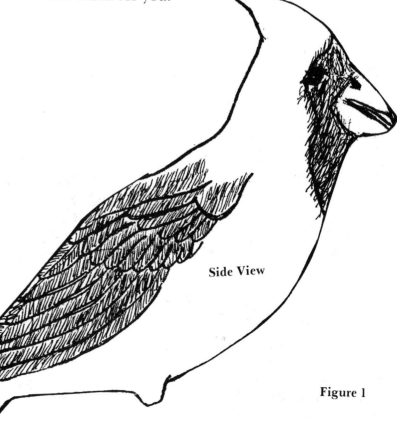

Side View

Figure 1

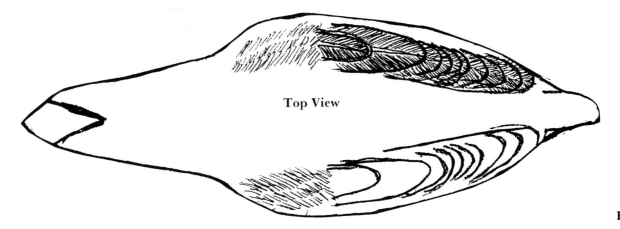

Top View

Figure 1

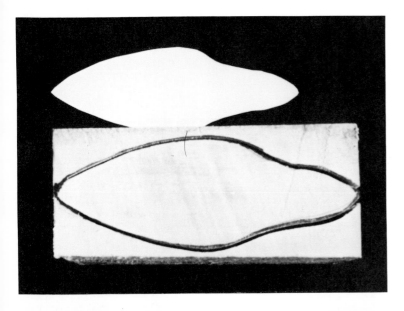

Figure 2

Trace the top view of the pattern on the basswood block.

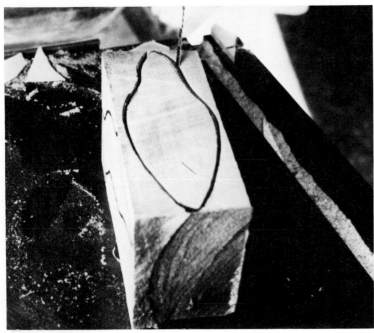

Figure 3

Cut this with the band saw. Do not cut the wood completely through at the tail and leaving the block intact.

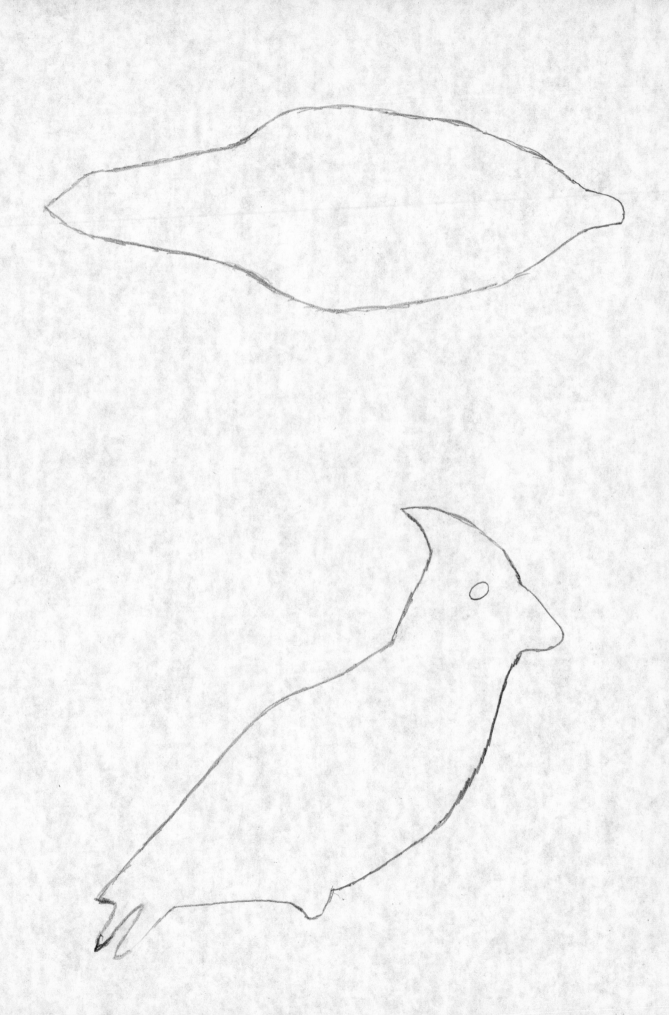

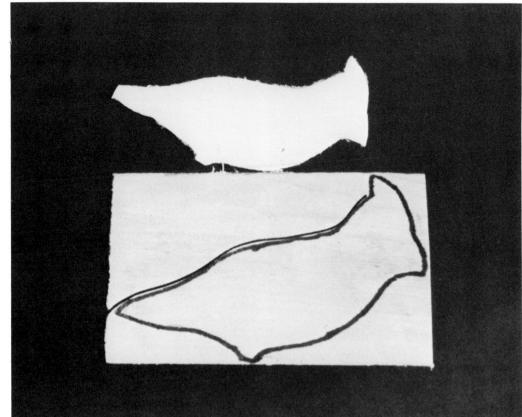

Figure 4

Trace the side view pattern on the block.

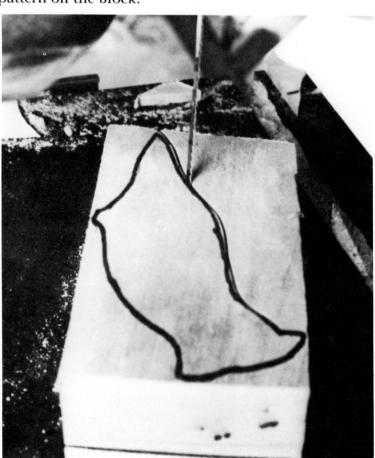

Figure 5

Complete the cutout using the band saw.

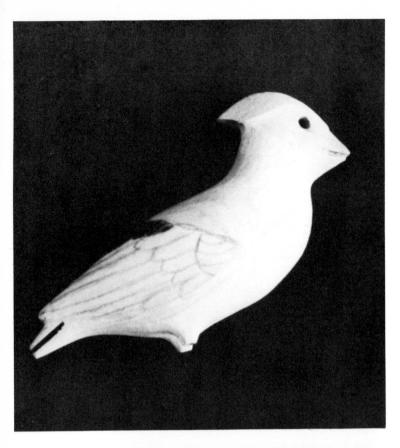

Figure 6

Place the pattern on the side view of the cutout and locate the eye socket on each side. Drill a quarter of an inch hole for the insertion of the glass eyes to be installed later. Note the slot for the tail feathers. This can be cut in at this time also. Using carving knives and a rotary grinder equiped with a sanding drum shape and smooth the crest, carve in the eye channels and round out the beak.

Round out the body and the hips and sketch the wing feathers with a pencil.

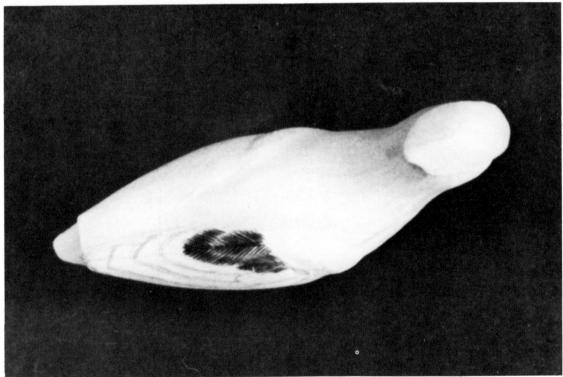

Figure 7

The carved top view of the cardinal. Note the peaking of the crest and the slight depressed areas from the shoulders to the tail which helps to define the side wing structures. Top view also shows the carved wing feathers. Burning the wing feathers is also shown in this view.

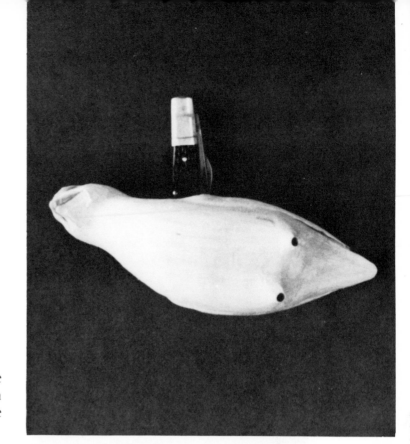

Figure 8

The bottom view and the carving details. The 1/8'' holes have been drilled to accept the legs in the carved and rounded hip area. Note again the area of the side wings has been well defined.

Figure 9

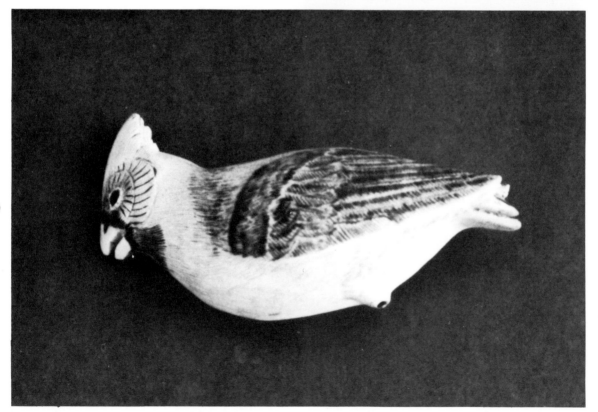

Texturing and finishing of the side view of the cardinal. Note the slightly open beak and nostril hole burned on the beak. The 6 millimeter eye has been installed by using epoxy putty to form a slight eye lid. A higher setting is used to get a darker burn on the side wing feathers, the shoulders, and the dark area under the bill and on the head. The remaining areas are textured using a low setting on the burning pen. This aids in the painting of the cardinal since the lighter areas are on the chest, the rump, and the neck.

10

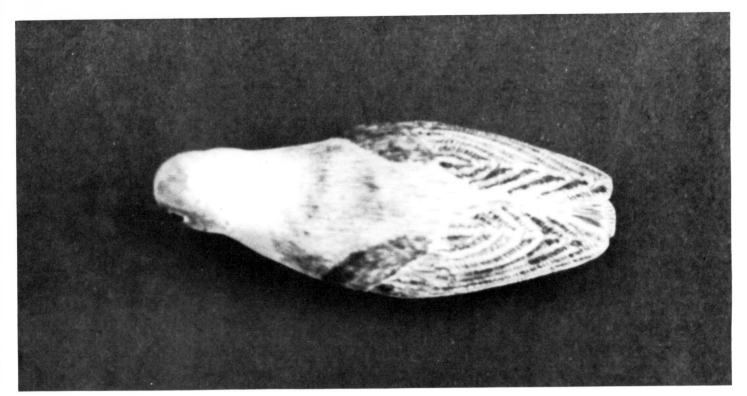

Light and dark areas textured on top view.

Figure 10

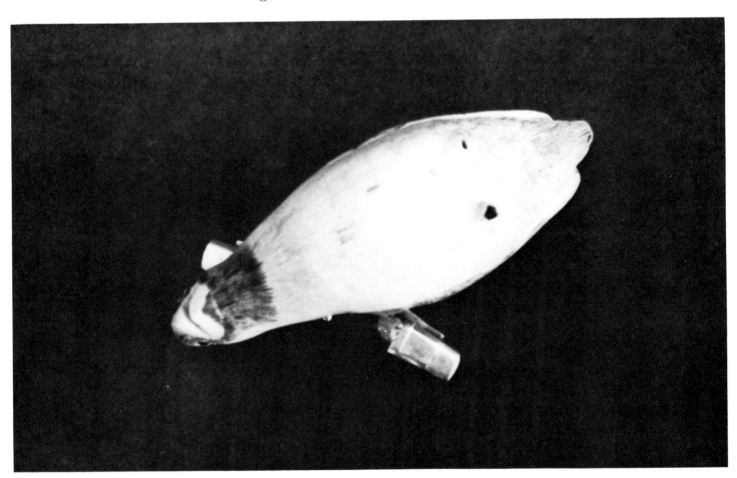

Texturing of the light and dark areas on the
bottom view.

Figure 11

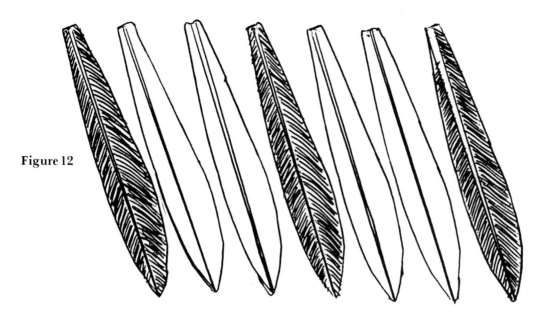

Figure 12

Using pattern shown here trace seven tail feathers on 1/64'' birch plywood.

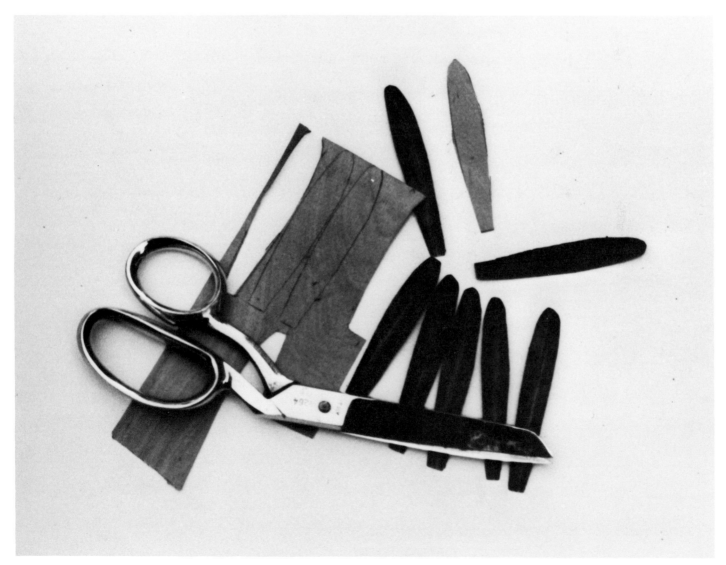

Figure 13 Cut out with scissors.

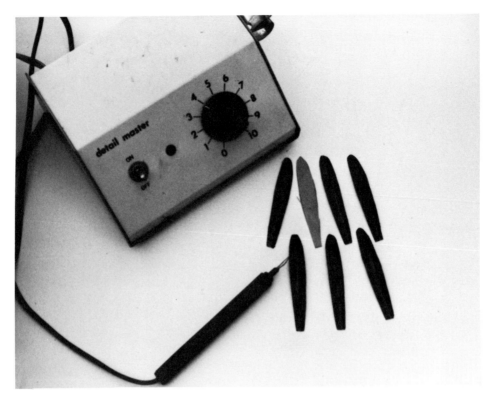

Figure 14

Using a setting of 4 on the detail master burn the feathers as shown in figure 12. Texture the top side of the feather first and the bottom side last in order to make the feather curl slightly down as shown in figure 15.

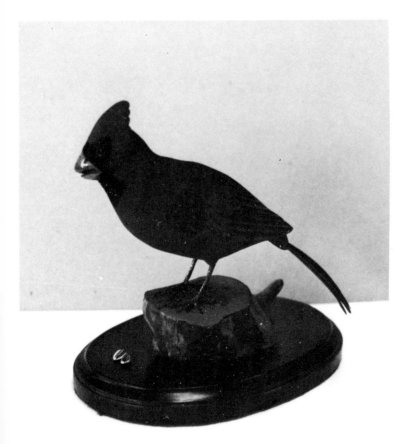

Figure 15

The finished cardinal. Using cadmium red light prepare a wash using one part paint and one part water. Paint the top of the tail feathers with this mixture and dry with hair dryer. Then paint the feathers underneath. Now install the feathers using superglue. The center feather is upper-most as shown in figure 16. Using the same red mix, put several washes over the entire bird except in the dark area above and below the beak. After each coat, dry the bird with your hair dryer. Paint right over the darkened area on the shoulders and wings. Paint the black patch on the head with a mix of mars black with a touch of blue. Paint the feet and legs with cadmium red light and install using superglue. Now paint the beak with a mix of cadmium red light with a touch of yellow. Be certain the beak is sanded smooth before painting. Put on about five coats. Dry well with hair dryer and finish with clear nail polish. (see color figure 15).

Figure 16

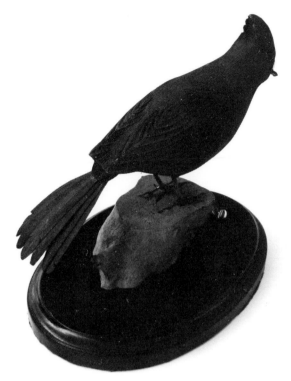

Note the contrast in the darkened areas where the texturing was done with a 4 setting on the rheostated burning pen. The lighter areas were done with a setting of 1 1/2. Note the carving of the crest. (see color figure 16).

Figure 17

Note the slight breaks in the tail feathers to add realism and texture patterns of the wing feathers. (see color figure 17).

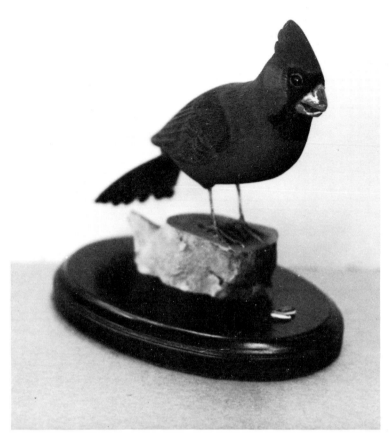

Figure 18

The cardinal is mounted on driftwood and a finished base. A sunflower seed is placed in the beak. Two sunflower seeds are glued to the base. (see color picture on front cover).

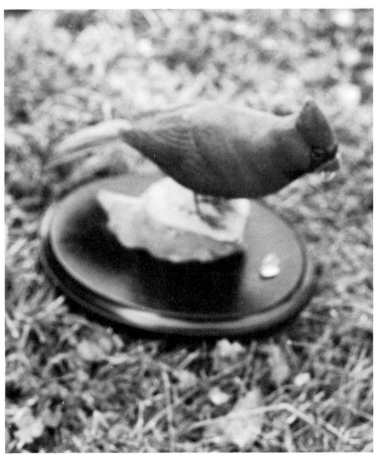

Figure 19

The cardinal out in his natural habitat where his color and song are most attractive.

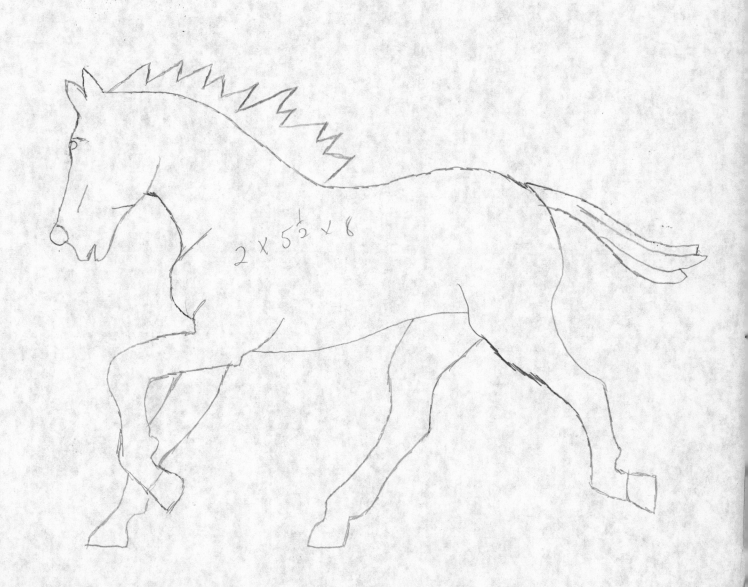

2 × 5½ × 6

The Horse

Materials Needed

Basswood block
 2'' x 5½'' x 8''
Band saw, coping saw or jigsaw
Carving knives
Sandpaper

Sealer (Acrylic clear spray)
Paint brush No. 2
Rotary Grinder or flexible shaft grinder
Burning pen
Glass eyes (4 mm)

Epoxy putty
Acrylic paint
 Mars Black
 Burnt Umber
Hair dryer

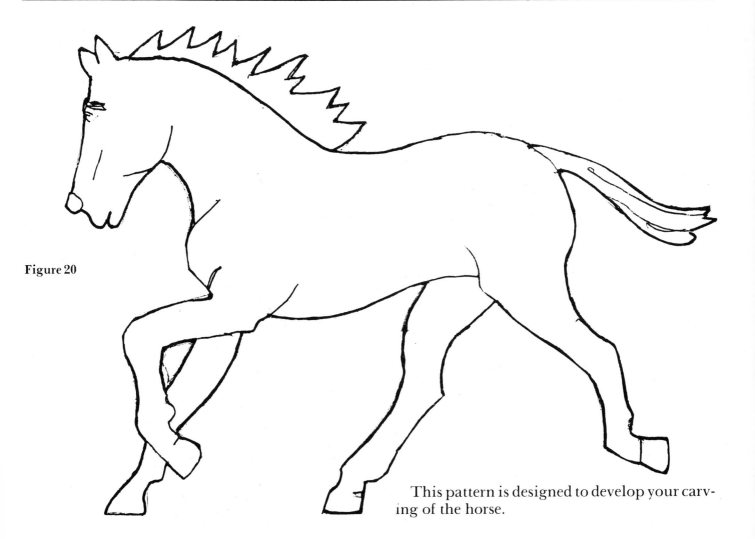

Figure 20

This pattern is designed to develop your carving of the horse.

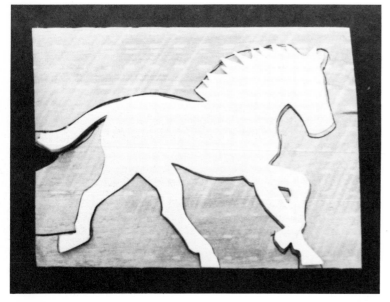

The horse has been one of man's most dependable friends and servants for thousands of years. Horses can live in almost any climate. They gallop over the burning sands of the desert and pull sleighs in lands of snow and cold. Horses carried pioneers across the American plains to settle the west in the days of the stagecoach. I have picked a horse of this breed for you to carve because it has strength, power, speed, and endurance.

Figure 21

Tracing the pattern on the basswood block.

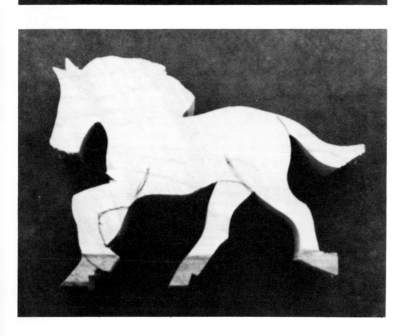

Figure 22

Cut out the horse with a band saw from the basswood block and the resultant cut out is shown in figure 23.

Figure 23

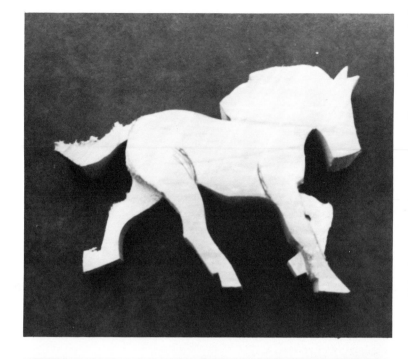

Figure 24

Shows the wood removed from the legs of the right side of the horse. The cut out actually leaves eight legs on your horse. Using sharp knives or a rotary grinder with a medium grit sanding sleeve, cut away the excess wood from the rearmost leg. This leaves a single leg remaining on the left side. Now cut away the wood from the bent front leg on the right side. Round out the remaining two legs, the thighs, and hips on the right side.

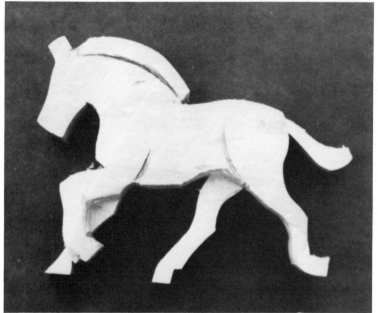

Figure 25

Removal of the legs on the left side of the horse is shown. The excess wood that remains on the two legs that are straight and not in a bent position is cutaway with the knife and smoothed out with the rotary grinder equipped with sanding drum. Mark with your pencil the area which must be removed in order to make no mistaken cuts. Cut away the excess wood on the tail and mane leaving 1/4" of wood that can be shaped later.

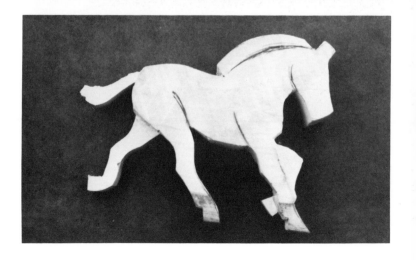

Figure 26

Carve the hips, round out all four legs and shape the neck as shown.

Figure 27

Pencil markings defining the excess wood on the head and between the ears. It also shows the wood cut away from the tail.

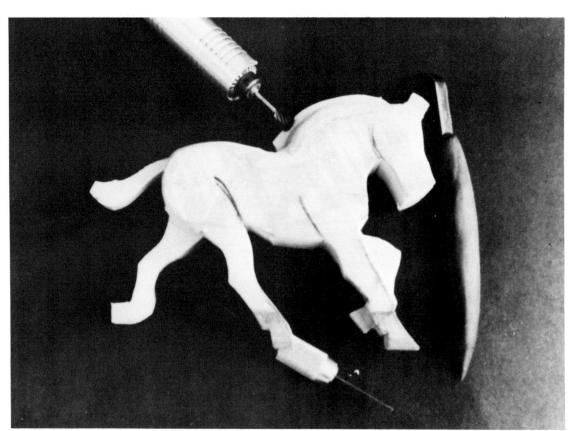

Figure 28

A flexible shaft grinding and carving tool being used to shape the mane, tail, and cut out the excess wood between the ears as shown on top view in figure 29.

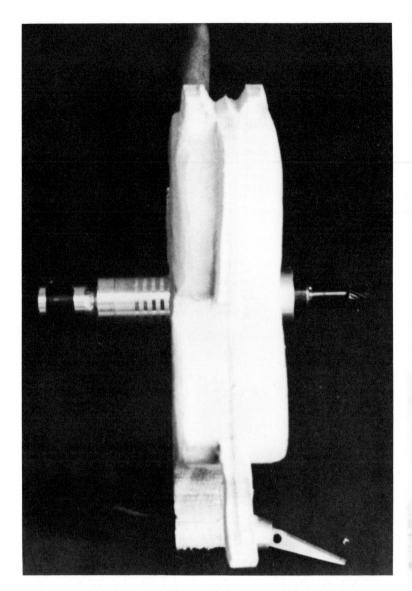

Figure 29

116 121 115 125 193 114

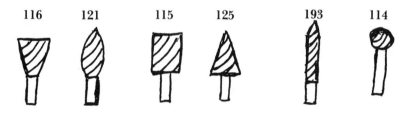

High speed cutting heads

Figure 30

A selection of high speed cutting heads and drum sanders are shown that can be used with rotary grinders or flexible shaft grinders. The cutting heads can shape and carve many difficult areas on the carving where it may be difficult to carve with a knife. These attachments may be obtained at a hobby shop. The drum sanders speed up smoothing and sanding.

Drum Sander #407

Sanding Band 408
Sanding Band 432

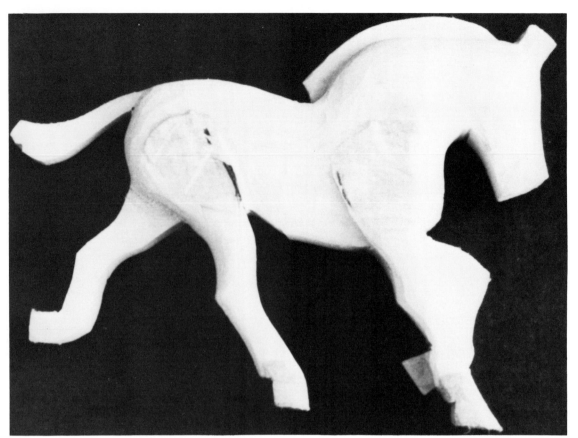

Figure 31

Carve the neck and start to shape and round out the head and ears. Round out the stomach between the front and rear legs.

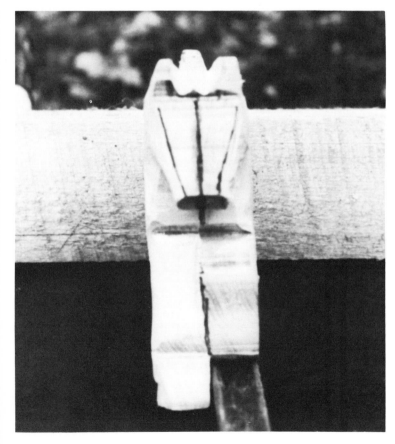

Figure 32

Mark the center line of the head and the limit lines to shape the head and carve off the excess wood.

21

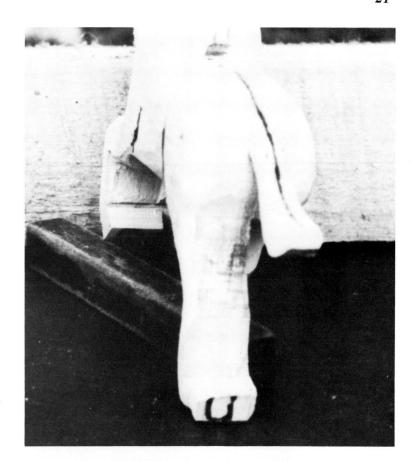

Figure 33

Round out the rear hips and mark the hoof of rear leg to actual size. Carve the areas after these marks are made.

Figure 34

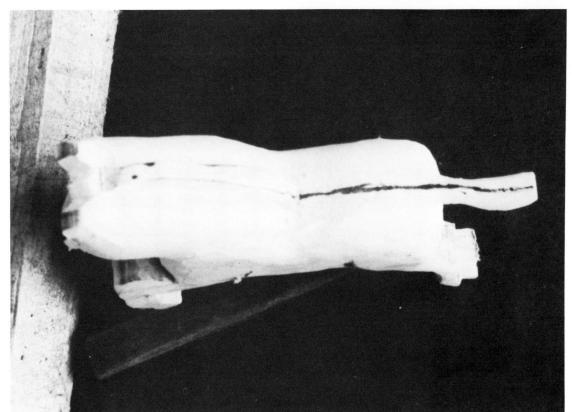

Mark the center line of the tail and round and smooth the top of the horse with the drum sander.

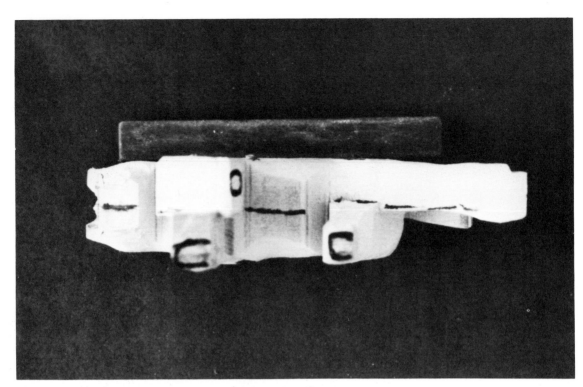

Figure 35

Mark the hoofs on each leg and carve and shape the hoofs while separating the legs as shown in figure 36.

Figure 36

Figure 37

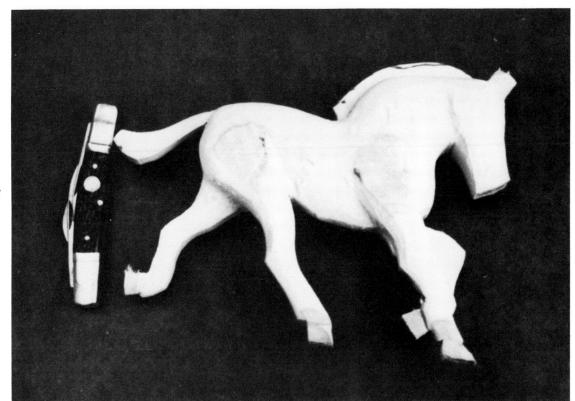

Begin to shape and smooth the entire carving using a very sharp pocket knife, sanding paper, and a rotary grinder equipped with a drum sander with fine grit. Carve the excess wood from between the legs, round out and smooth the legs and hips. Carve the head with eye channels, mouth, and ears shaping the outside and inner ear cavity. Look at a picture of a horse's head as you do this part. Shape the mane and have your horses right side looking like figure 38.

Figure 38

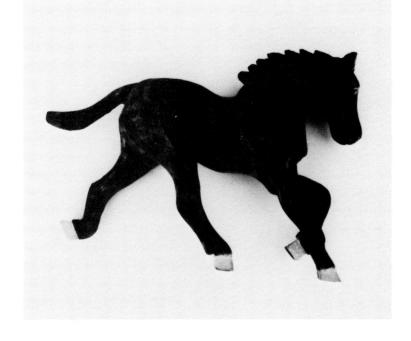

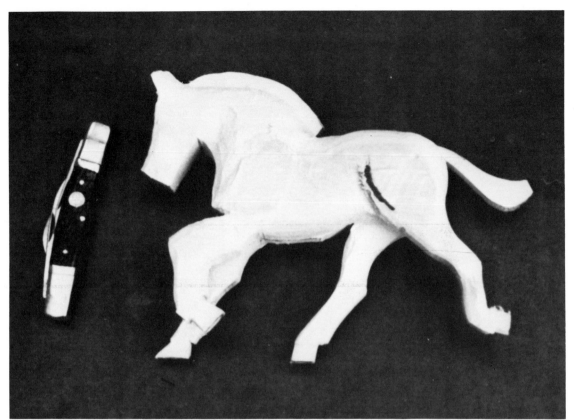

Figure 39

Shows the state of the carving prior to going through the same steps as is outlined on the right side.

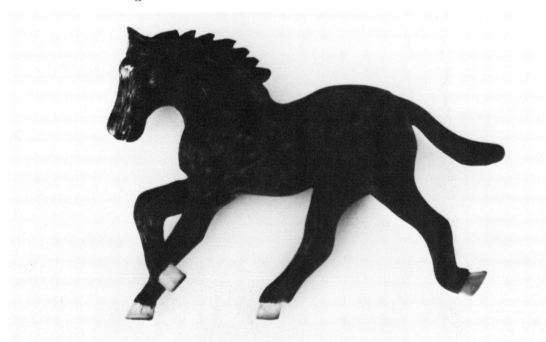

Figure 40

The detail of the carved, smoothed and textured left-hand side of the horse. Note the drilled eye socket for the 4 millimeter glass eye. Note also the hoofs have not been textured with a burning pen.

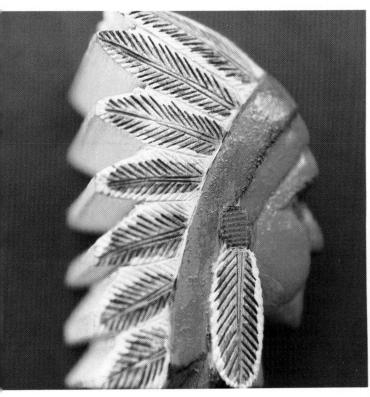

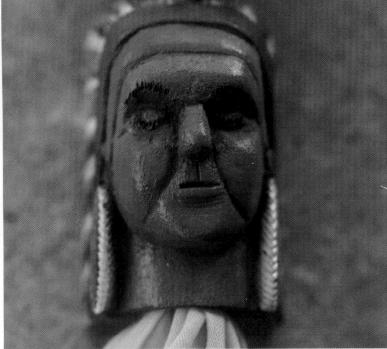

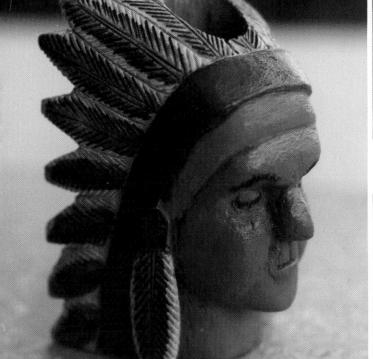

Indian chief color figure 60.

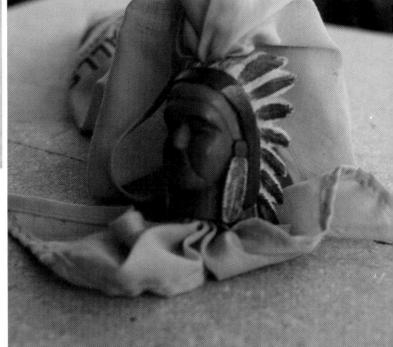

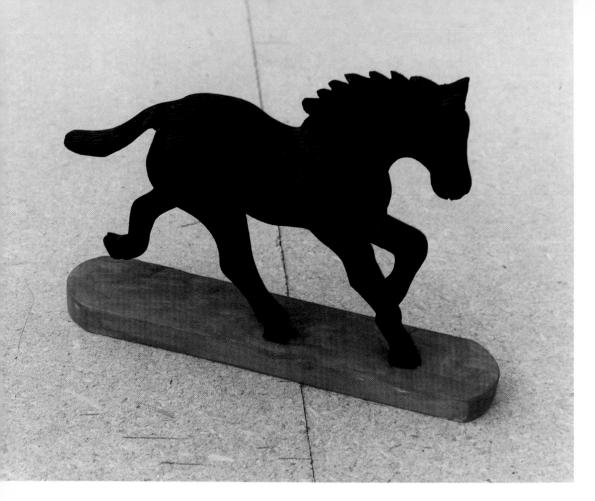

Horse

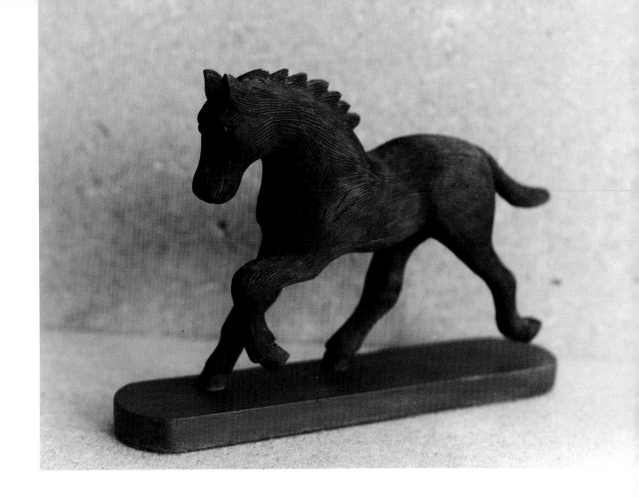

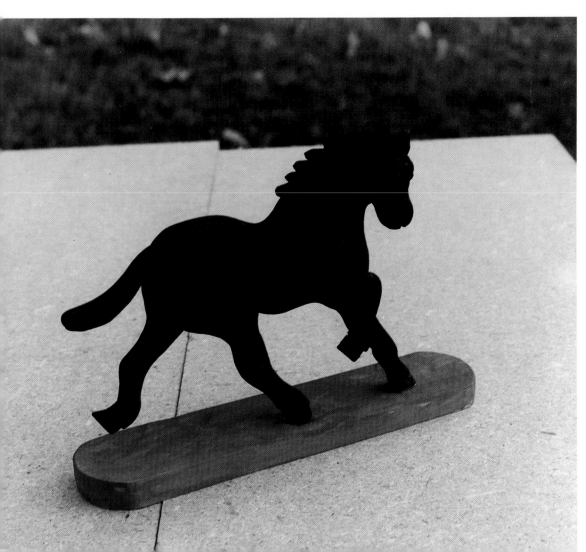

Horse color figure 43.

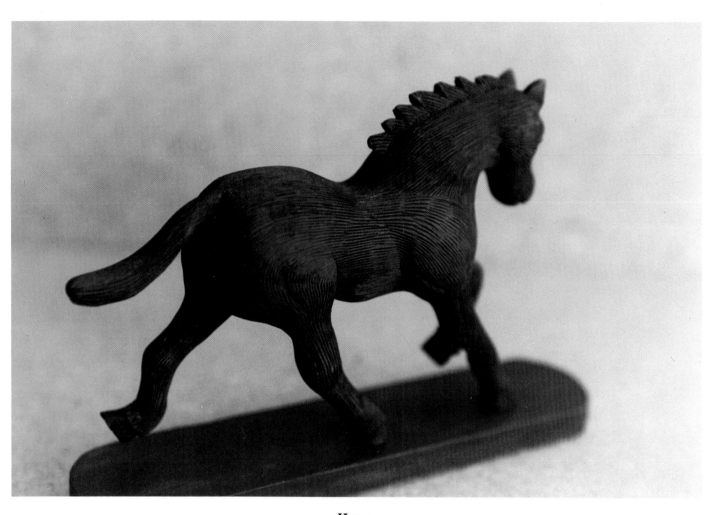

Horse

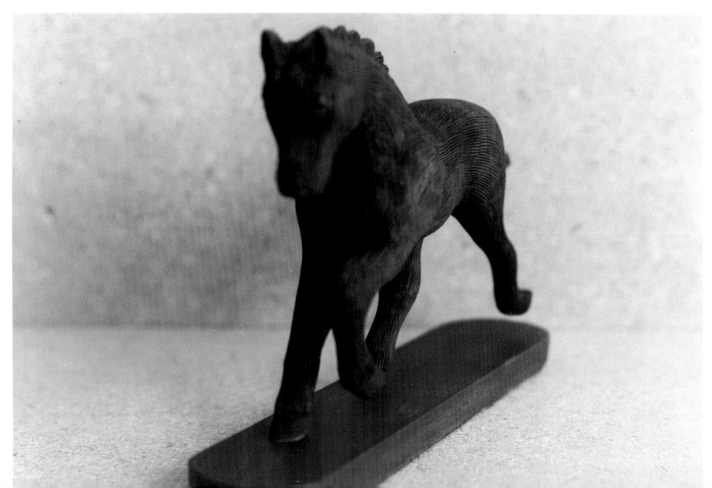

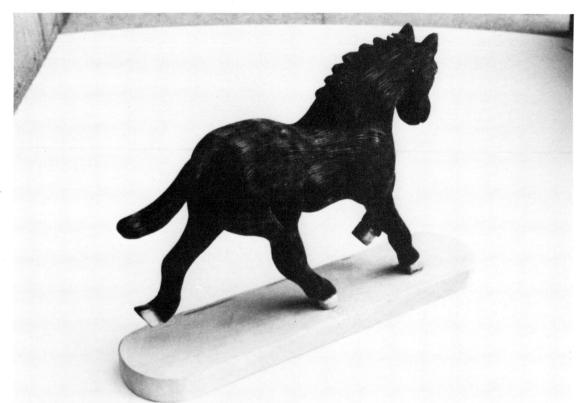

Figure 41

Shows the horse after it has been textured with the burning pen. Make the strokes of the pen with short slightly curved lines. Move slowly through each stroke to get a deeper, dark, compact burn. Follow the contours of hips and legs as the flow of the fine hair on the horses hide. Fill in the eye socket with epoxy putty and insert the glass eyes which should be dark brown.

Figure 42

The shape of the finished top view of the horse. Cut and shape a 3/8" block of basswood to mount the horse using fine screws through the base into the hooves of the horse.

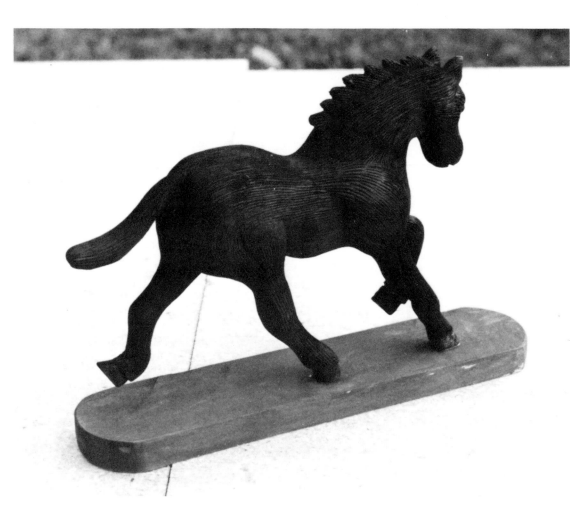

Figure 43

Brush the carving with a brush to remove the charcoal left by the burning process. Spray with acrylic clear sealer and dry with a hairdryer. Make a mix of burnt umber and mars black—equal parts and paint the horse throughout except for the hooves. Use several washes—drying after each wash with the hair dryer. Paint the hooves mars black and highlight the hips with burnt umber. (see color figure 43).

The Indian Chief

Materials Needed

Basswood block
 1¾" x 2" x 2¾"
5/8" Drill bit and drilled band saw or
 coping saw
Carving knives
Power Dremel Moto Tool No. 280
High speed cutters shown in figure 30

Acrylic paint
 Red
 Blue
 Green
 Black
 White
Acrylic clear sealer

Drum sanders with sanding sleeves
Sandpaper
Paint brushes No. 0, No. 1, No. 2
Burning pen
Hair dryer
Pen, pencil

Traditionally the uniform of the Boy Scouts of America includes a neckerchief. This can be used as an aid for a sling in emergencies, a tournequet, or a bandage. It is also decorative and adds a snappy appearance to the uniform when worn with a handcarved slide.

One of the favorite carved slides is the one of the Indian Chief with his feathered plumage.

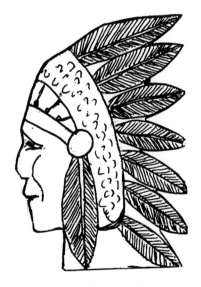

Figure 44

The pattern for making the carved Indian Chief neckerchief slide.

Figure 45

Basswood block.

Figure 46

Center top of block to drill 5/8" slide hole.

Figure 47

Drill hole with power drill and 5/8" bit.

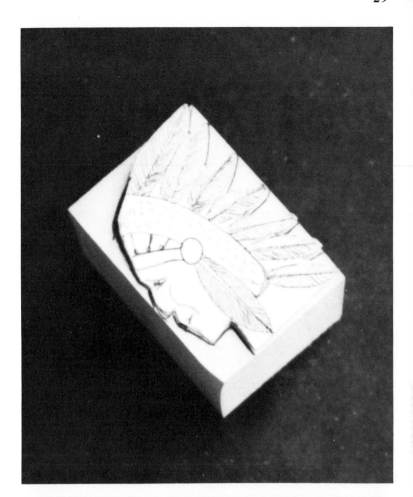

Figure 48
Figures 48 and 49. Trace pattern on side block.

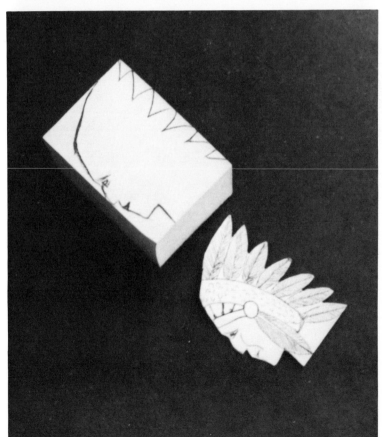

Figure 49

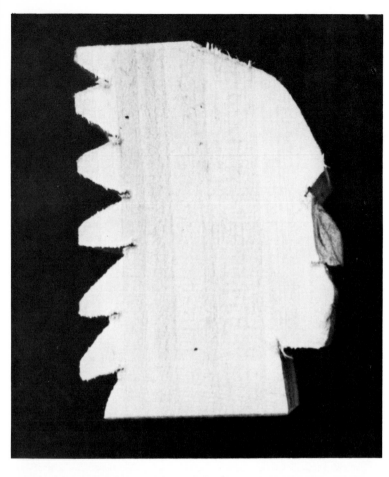

Figure 50

Cut out block using a band saw to define the facial features and headdress feathers.

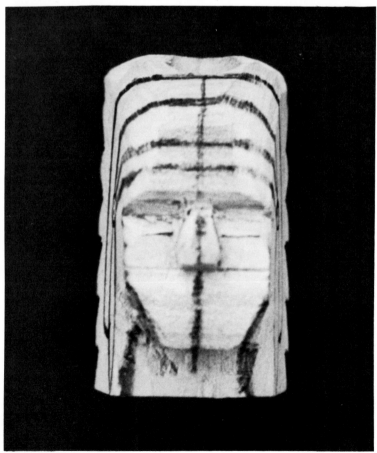

Figure 51

Draw the nose, cowl, feather band and neck in the center line. Using a well sharpened pocket knife, shape the nose, cut in the eye channels, and cut in the chin and cheeks.

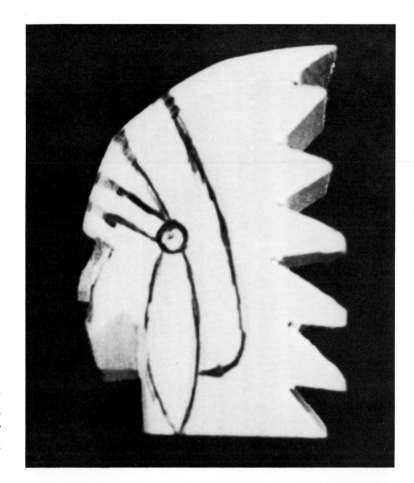

Figure 52

Shape the cheek, chin, mouth and eye channel. Note the tip of the nose is the most distant point to the east. Score with your knife all the lines shown in figures 52 and 53. Carve and define all areas within these lines.

Figure 53

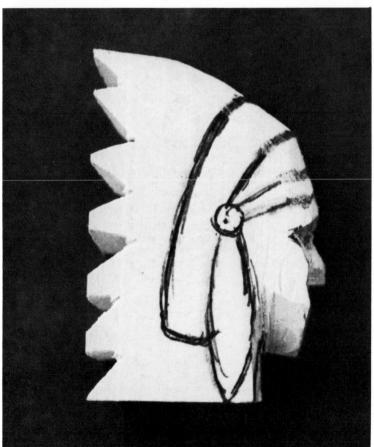

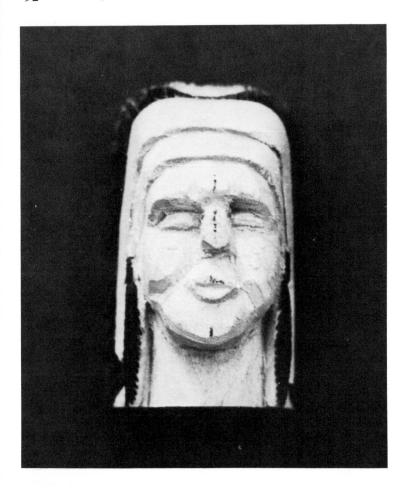

Figure 54

Proceed to do the detail carving of the closed eyes, the mouth, nose, cheeks and chin. Carve in the head band and shape the Indian Chief's brow. Use a sharp knife and sanding board with fine grit.

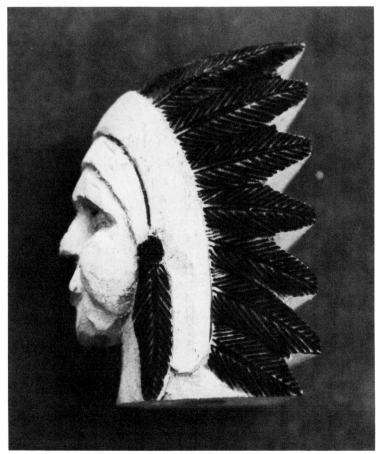

Figure 55

Side view of the facial features, feathers and head band. Note the protrusion of the upper lip and the round cheek. Note the carved definition of the hanging side feathers.

The fine burning of the feathers on the head-dress and hanging feathers are shown in figures 55-59. These feathers are designed with a center quill and closely compacted barbs flowing to the right and left of the quill.

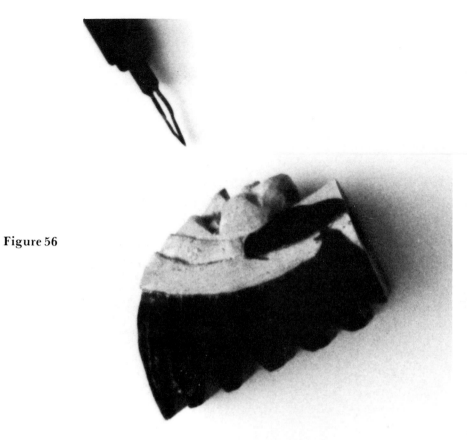

Figure 56

Figure 57

34

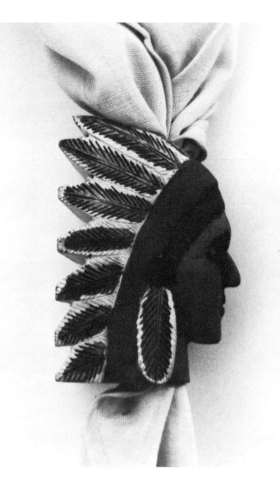

Figure 58

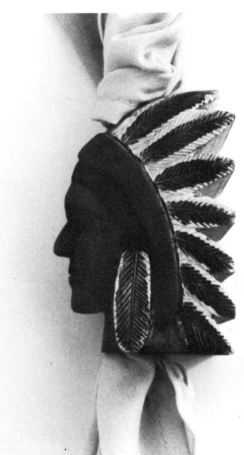

Figure 59

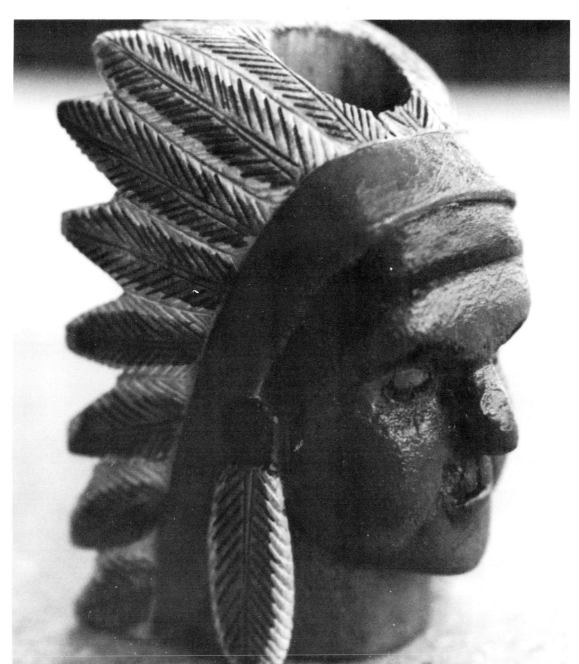

Figure 60

Brush thoroughly with a fine stiff brush over the entire carving to remove dust and charcoal. Spray with acrylic clear sealer and dry with a hair dryer. Paint all feathers white, the cowl green, the head band red.

Mix some raw sienna with the red to use on the face and obtain a redish brown.

Dry with hair dryer!

Repaint all areas a second and third time—drying after each coat.

Using mars black lightly paint the center of each feather to acquire a realistic feather.

Dry with hair dryer!

Lightly burn in eye brows and eye lashes to add more realism. (see color figure 60).

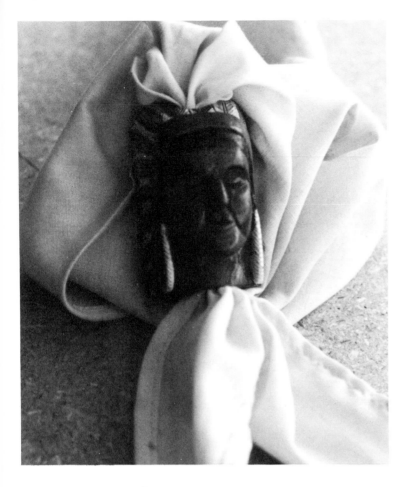

Figure 61

Figures 61 and 62 show the finished slide to add the snappy class to the uniform.

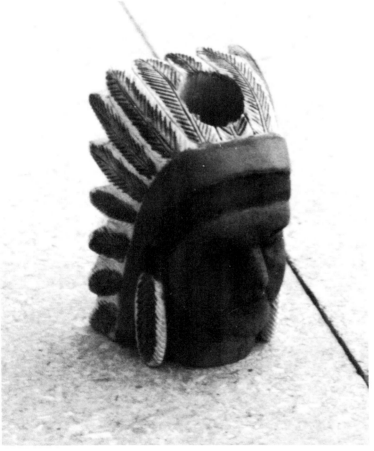

Figure 62

The White-tail Deer (Relief Carving)

Materials Needed

3 blocks of basswood
 3/8" x 7¼" x 8¼"
Band saw or coping saw
Glass eyes (4 mm)

Burning Pen
Moto Tool with cutting heads and
 sanding drum
Sandpaper

Carving knives and gouges
Farmby's Tung Oil
Stain (Cherry)
Quick setting glue

The white-tail deer is found in the forests of much of the United States and has survived many hunting seasons. Much of the time he moves noiselessly through the forests in his camouflaged coat except for his flashy white tail. His survival depends on man's balancing of nature by reducing the herd to permit ample natural food for the survivors.

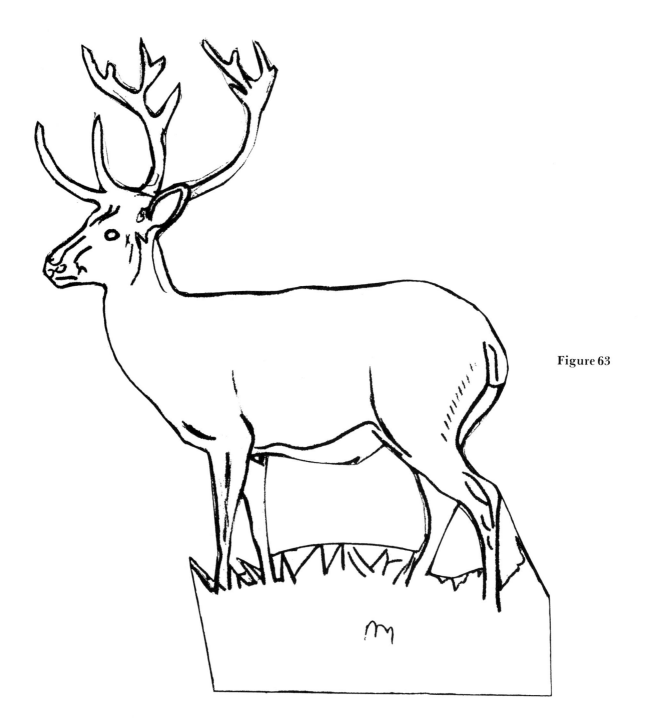

Figure 63

Figure 63 shows the pattern to be used to develop the relief carving.

Figure 64

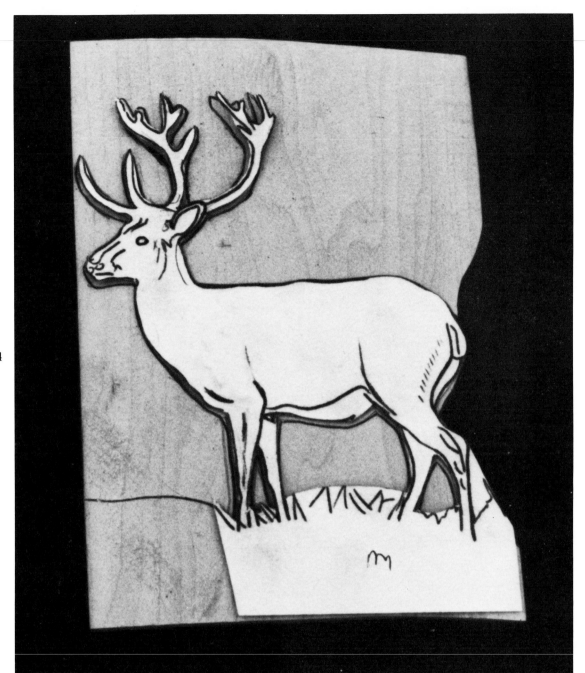

Trace deer pattern on one block of basswood.

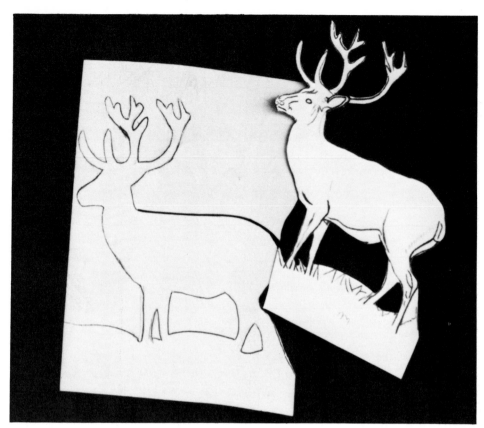

Figure 65

Cut out the deer figure with a band saw being extremely careful when cutting around the antlers and thin legs where a jigsaw may be most helpful in removing the excess wood at the three locations between the legs.

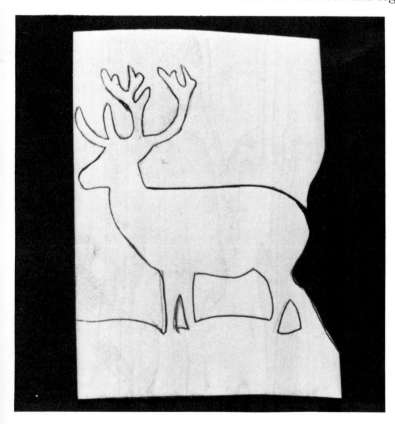

Figure 66

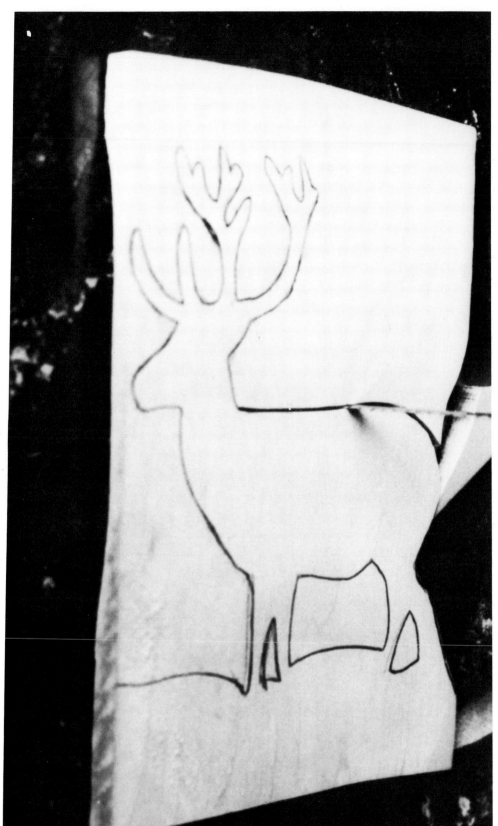

Figure 67

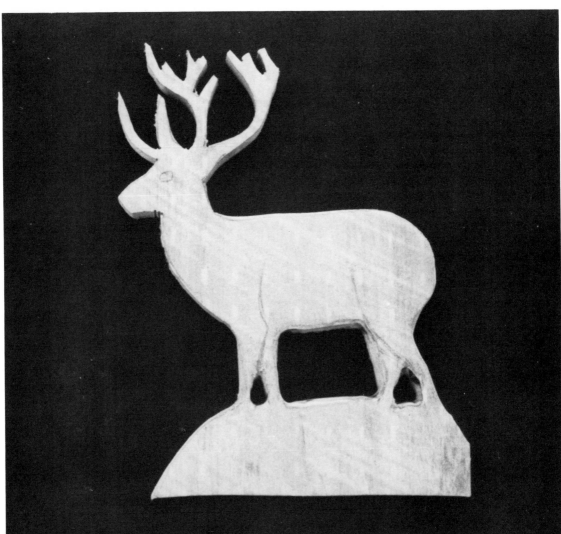

Figure 68

The completed cutout of the deer.

Figure 69

From one of the blocks of basswood cut out a frame of 3/8'' border for your plaque. Note the rounded corners of the inside of the frame.

Figure 70

Sand and match the frame with the background piece. You now have the three parts for the relief carving—the deer, the background, and the frame.

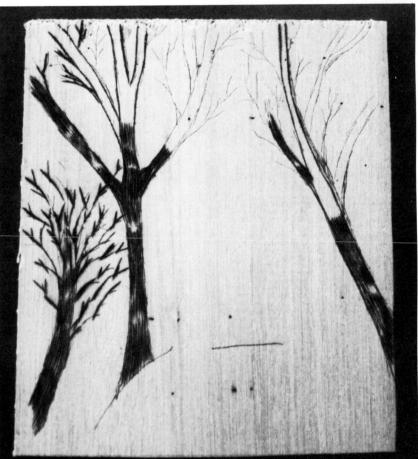

Figure 71

Sketch wintry trees on the background and
burn in the bark and limbs of the trees.

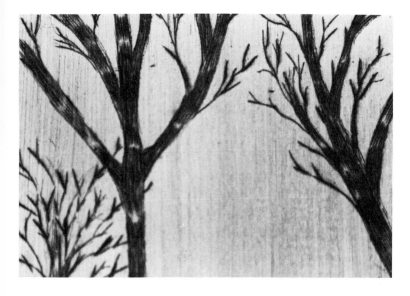

Figure 72

Close up view of textured trees.

Figure 73

Using the rotary grinder with a #125 cutting head round out the legs of the deer and continue this shaping through the thighs and hips. Terminate this work at the tip of the white area above the stomach. Round out the stomach as shown in the area painted white. Carve in the white tail as shown. Round out the breast and neck as shown in white. Now, using the rotary grinder round out and smooth the grassy knoll. Use the drum sander with fine grit sleeve.

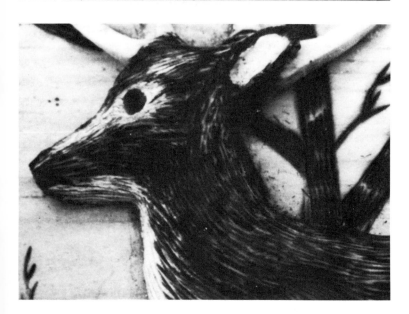

Figure 74

Round out the head with the drum sander. Cut in the ear cavity using cutting head #121. Drill the eye socket using #125. The resultant hole should permit the 4 millimeter eye to slide in with slight clearance. Carve and shape the ear and carve in a slight eye channel as shown.

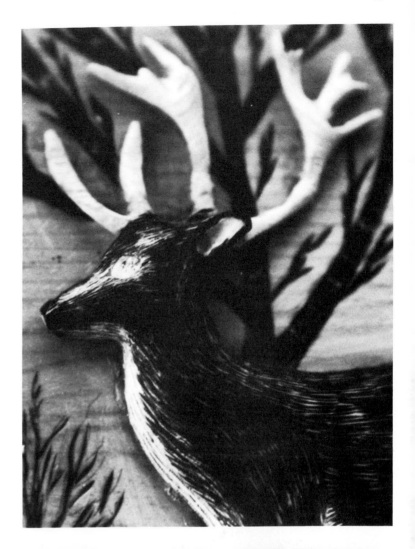

Figure 75

Figures 75 and 76 show the last step of carving the antlers—care must prevail or the antlers can be broken off and require glueing. Note the antlers have been rounded and sanded throughout and shaped to be three-dimensional. In figure 75, epoxy putty has been placed in the eye socket. At this time the deer is glued to the background and the dark brown eye is seated in the eye socket and a slight lid is shaped with the excess putty. The carving is now textured with a burning pen, brushed with a fine brush, and the white areas painted with acrylic white. (see color figure 76).

Figure 76

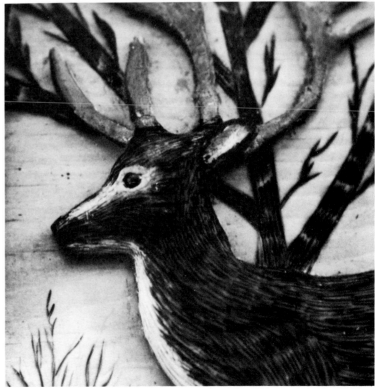

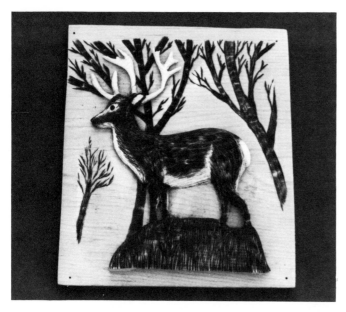

Figure 77

Note the texturing of the high grass on the knoll and the camouflaged position of the deer with the woodsy background.

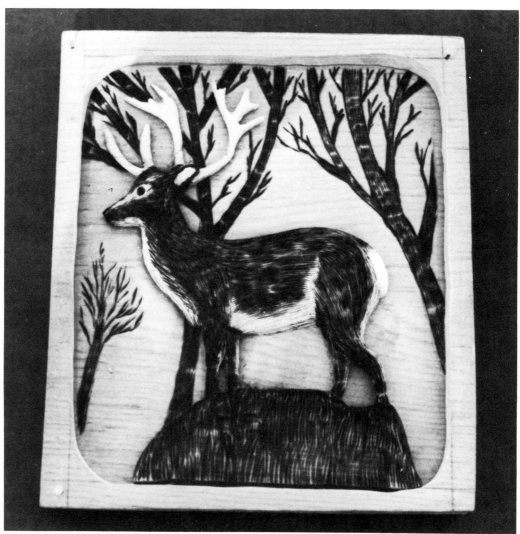

Figure 78

Install the frame on your relief carving and brush the background and dark areas of the deer with tung oil. You may desire to stain the frame with cherry or walnut stain.

David E. Pergrin graduated from Pennsylvania State University in civil engineering. He commanded the legendary 291st Engineer Combat Battalion in World War II and was a Civil Engineer in the railroad industry for 35 years. He retired from his engineering career in 1979 when he served as an adviser to the Federal Rail Administration. He developed an Engineering Consulting Firm during the last 10 years of his active career.

Mr. Pergrin has been teaching wood carving for 15 years to the Boy Scouts of the Valley Forge Council in Pennsylvania. He developed the wood-carving program at the Scout Council's camp at Resica Falls where 500 boys each summer are involved in the program to receive their Wood Carving Merit Badge. The teaching of wood carving to the 7th and 8th graders at St. Johns Chrysostom Catholic school in Wallingford, Pennsylvania

has developed many fine carvers in the past 7 years. He also enjoys teaching adults, both retired men and women as well as active persons in the working world. He feels that wood carving is an excellent therapy for all ages. *Woodcarving the Wonders of Nature* has been taught by Mr. Pergrin at the Nether Providence community classes, the Elder Craftsmen in Philadelphia, Pennsylvania, and at Tyler Arboretum in Lima, Pennsylvania.

In the course of his teaching career, Mr. Pergrin estimates he has instructed more than 10,000 carvers, many of whom have gone on to receive ribbons in carving competitions. He developed plans for the first annual Boy Scouts of America Carving Show in Wallingford, Pennsylvania in 1984. The success of that show will make it a yearly event.

Other carving and related books available from the publisher. Write for a free catalog.

Decoy Carving Techniques for the Intermediate Carver, by George Barber and Larry Reader.
Complete Waterfowl Studies, by Bruce Burk.
 Volume I: *Dabbling and Whistling Ducks*
 Volume II: *Diving Ducks*
 Volume III: *Geese and Swans*
Waterfowl Carving: Blue Ribbon Techniques, by William Veasey and Cary Schuler Hull.
Waterfowl Painting: Blue Ribbon Techniques, by William Veasey.
Bills and Feet: An Artisan's Handbook, by William Veasey and Sina Kurman.
Blue Ribbon Pattern Series, by William Veasey.
 I. *Full Size Decorative Decoy Patterns*
II. *Miniature Decoy Patterns*
III. *Head Patterns*
IV. *Song Bird Patterns*
V. *Shore Bird Patterns*
VI. *Miniature Decorative Patterns*
VII. *Hunting Birds*
VIII. *Birds of Prey*
Blue Ribbon Burning Techniques, by William Veasey.
Waterfowl Illustrated, by Tricia Veasey.
Championship Carving, by Tricia Veasey and Tom Johnson.

Other books in the Carvers' Handbook Series:

Volume I: *Woodcarving the Wonders of Nature.* (Chickadee, Chipmunk, Turtle, Nativity Relief)
Volume II: *Carving the Wild Life of the Forest and Jungle*
 (Tiger, American Goldfinch, Woodmouse, Great Horned Owl-Relief carving)